S0-AJS-358

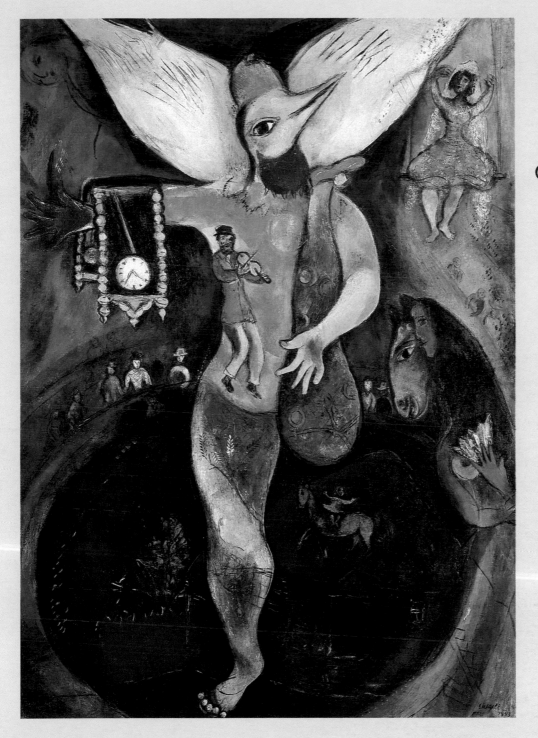

may i
feel
said he

poem by
E.E. Cummings

paintings by
Marc Chagall

edited by
Linda Sunshine

designed by
Mary Tiegreen

Welcome Enterprises, Inc., New York

may i *feel* said he

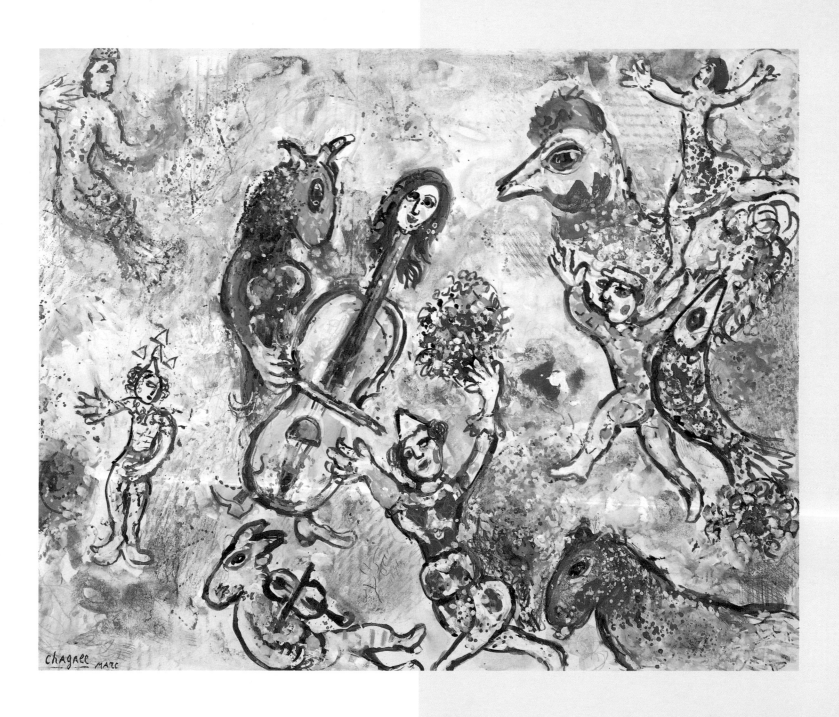

(i'll *squeal* said she

just once said he)

it's fun said she

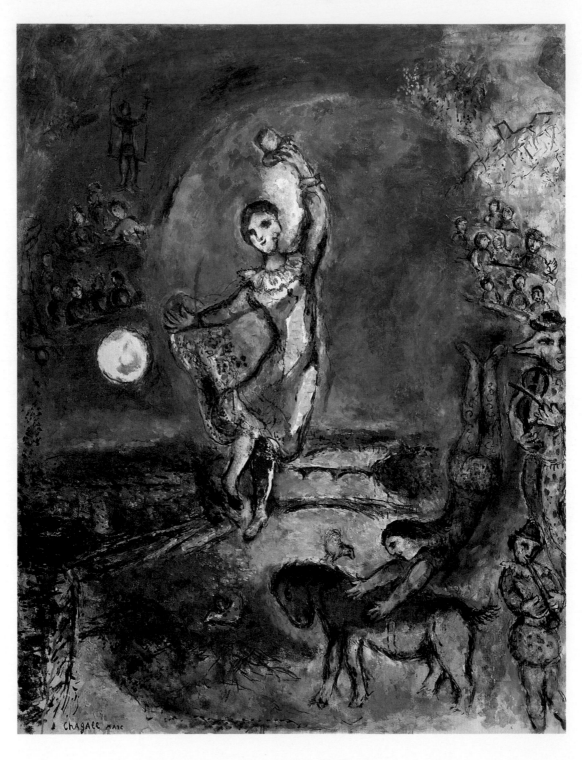

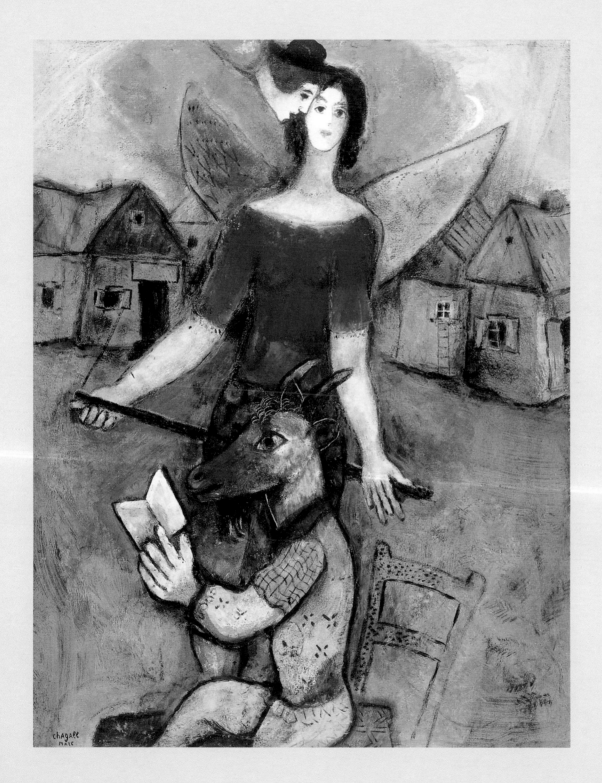

(may i
touch
said he

how much said she

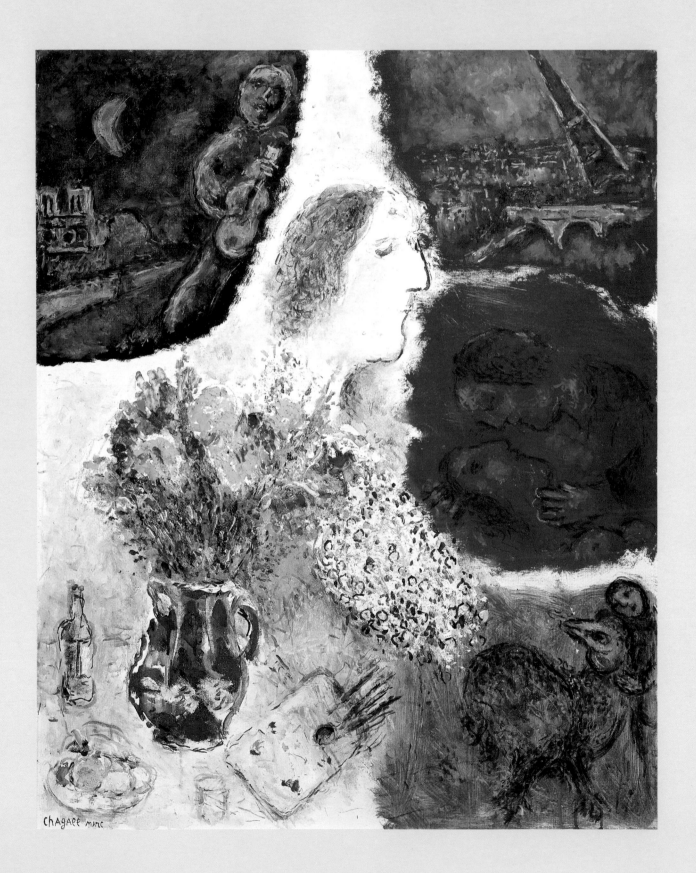

a *lot* said he)
why not said she

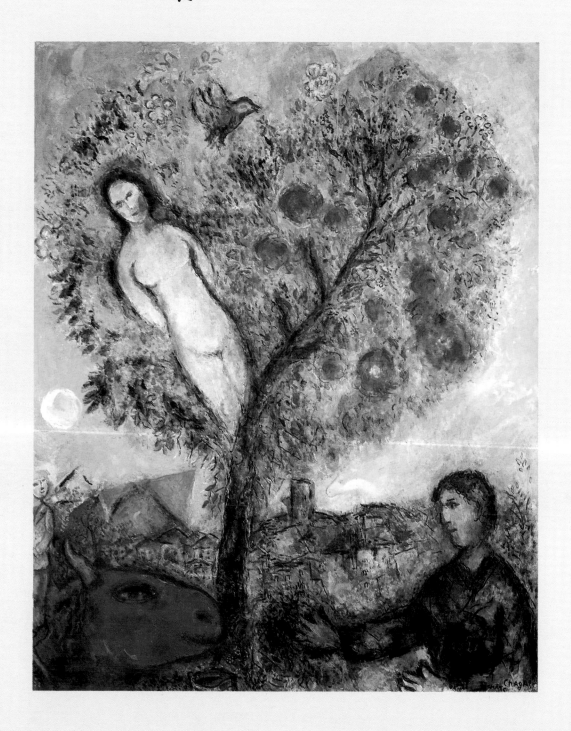

(let's go said he

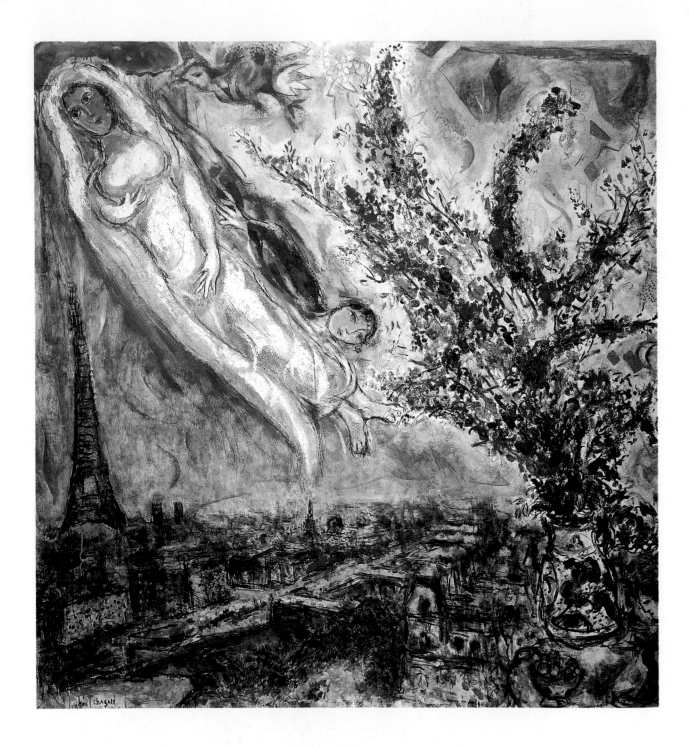

not too *far* said she

what's
too
far
said he

where
you are
said
she)

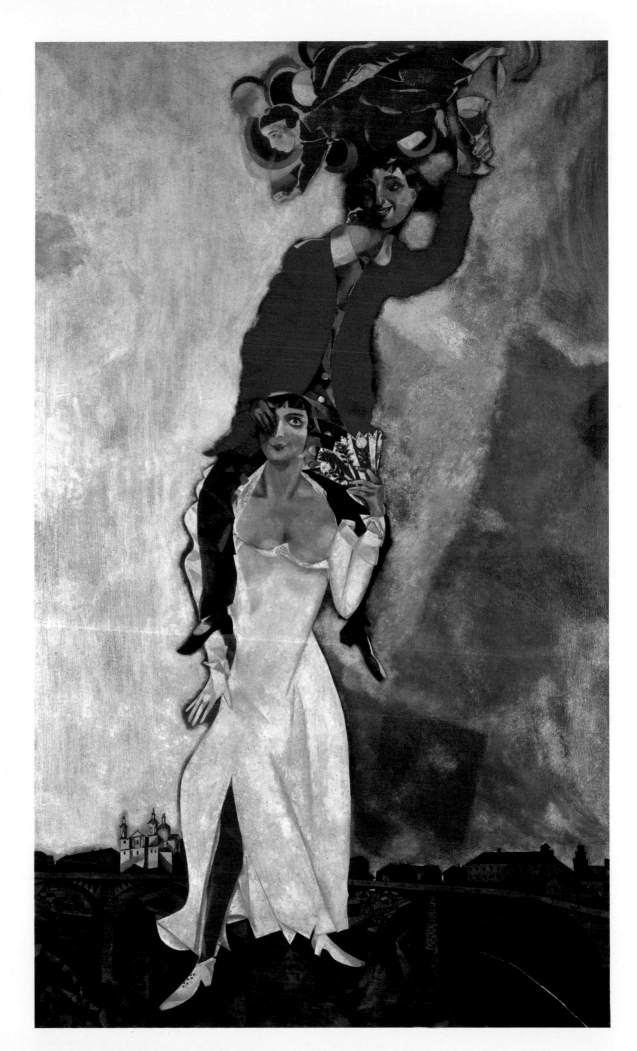

may i stay said he
(which way said she

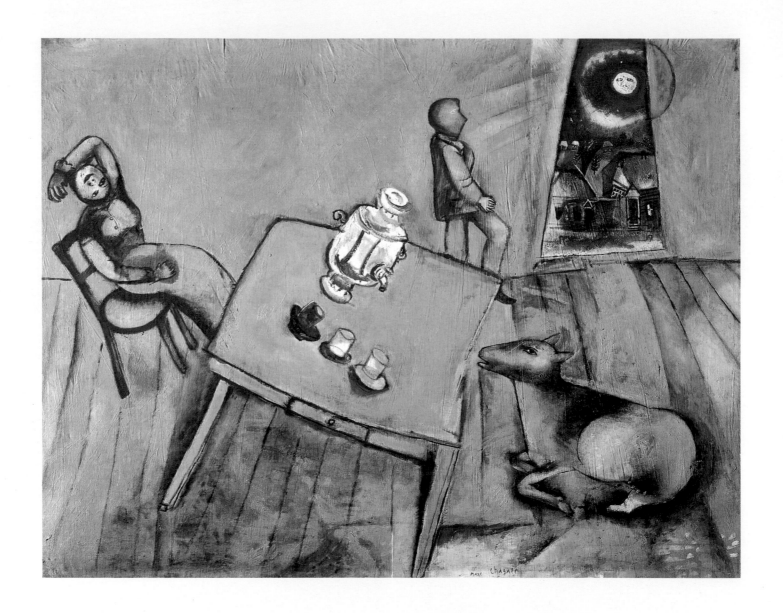

like this said he
if you kiss said she

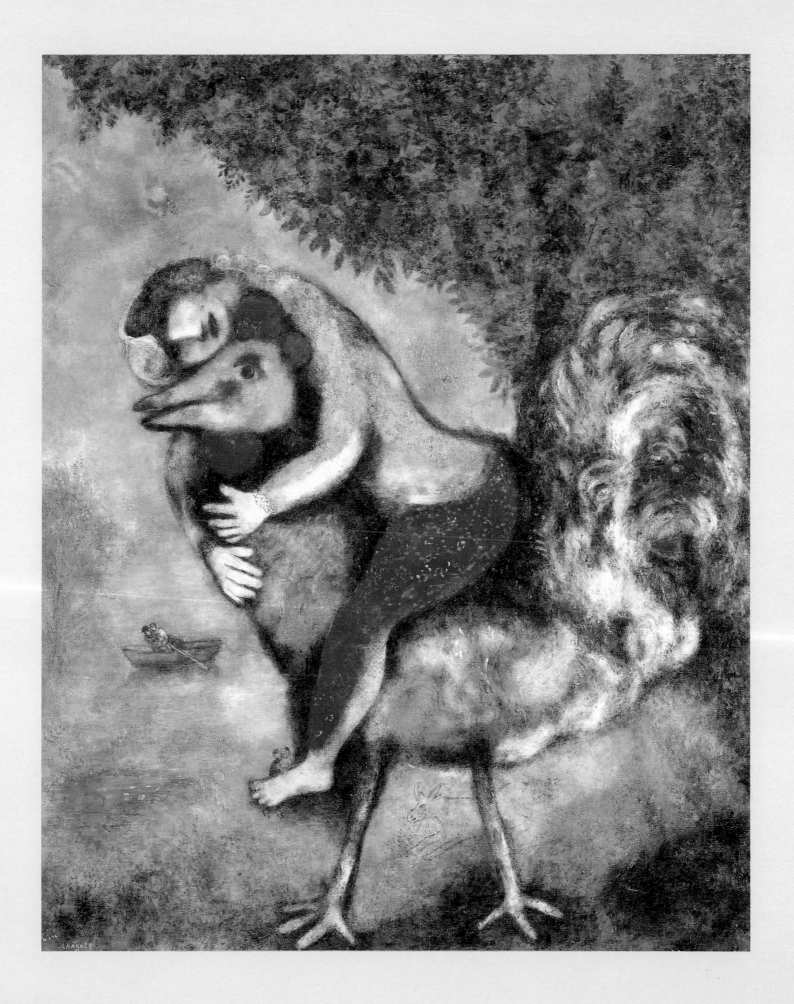

may i
move
said he

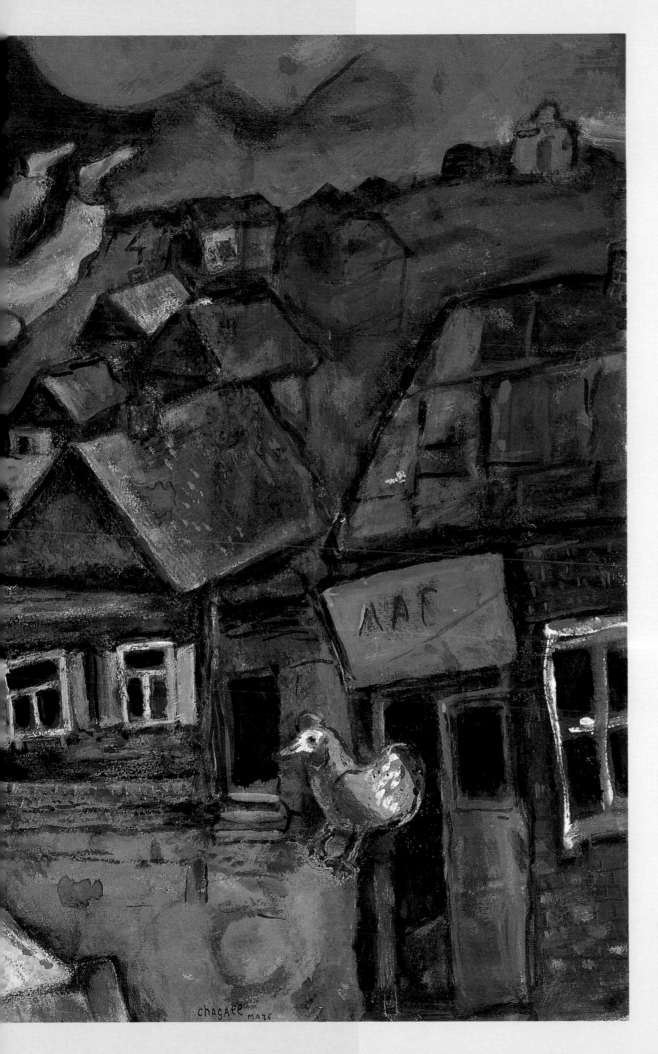

is it *love*
said she)

if you're *willing* said he

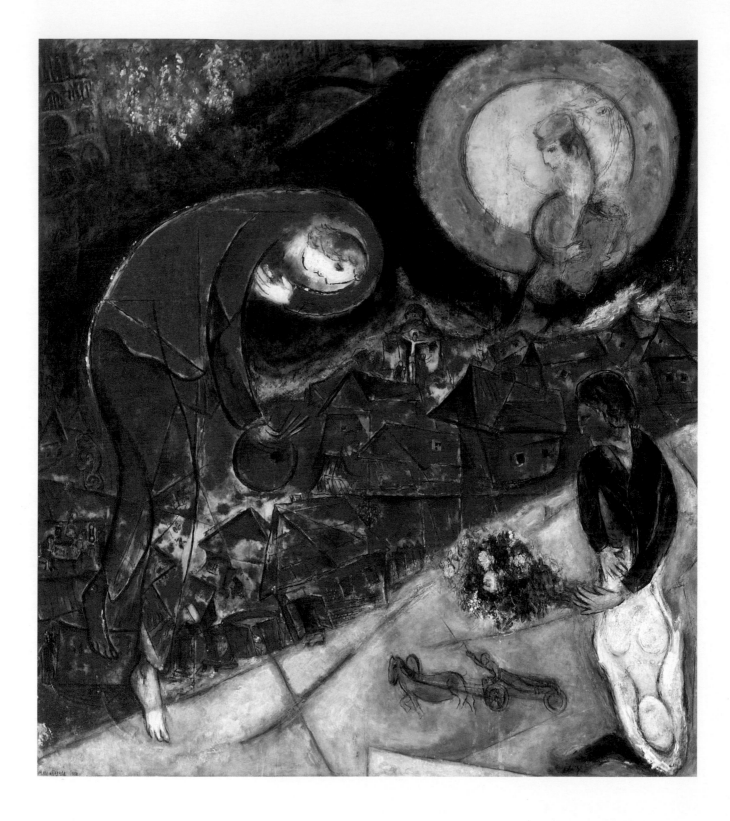

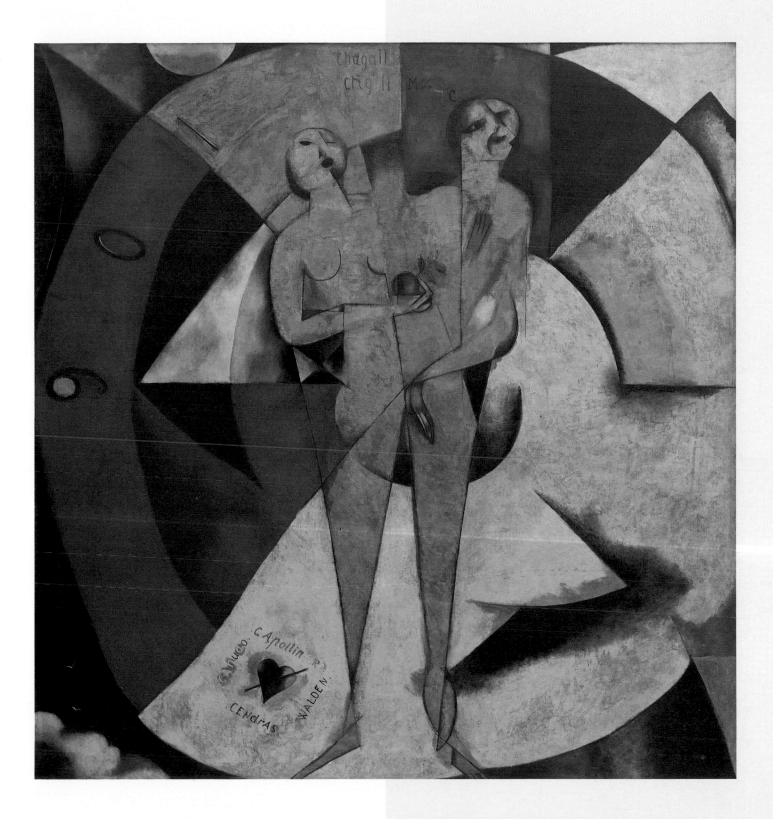

(but you're *killing* said she

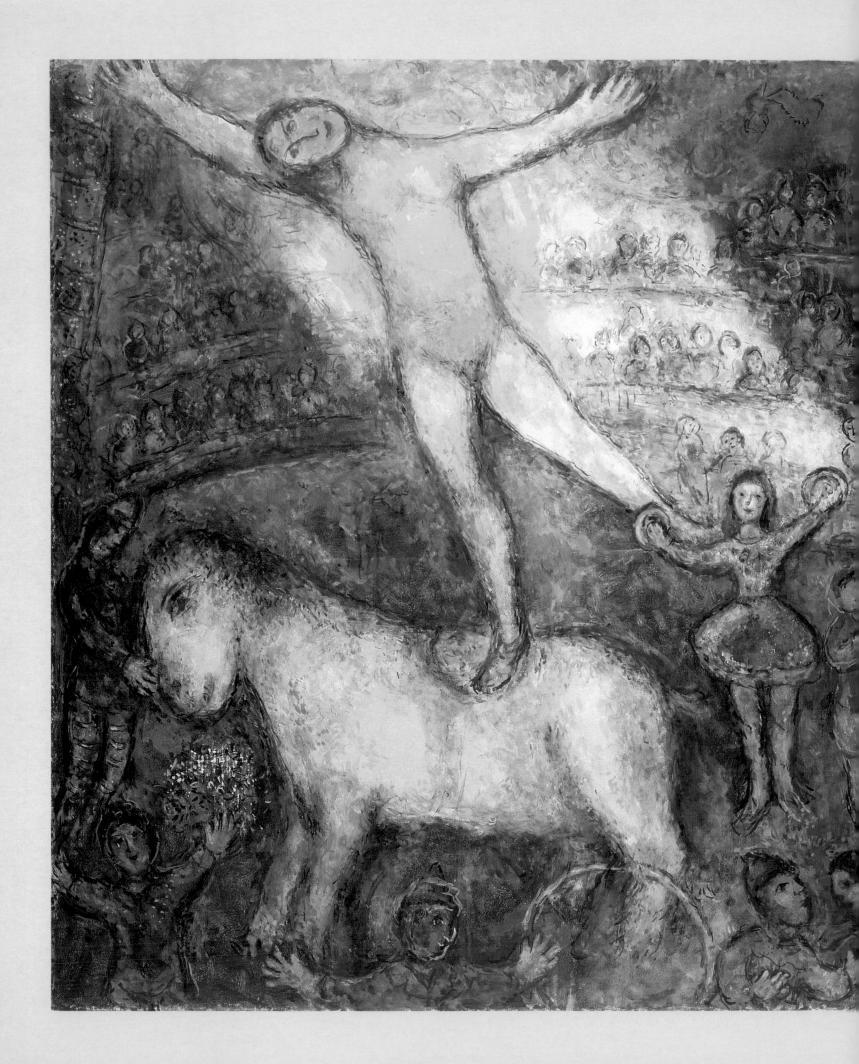

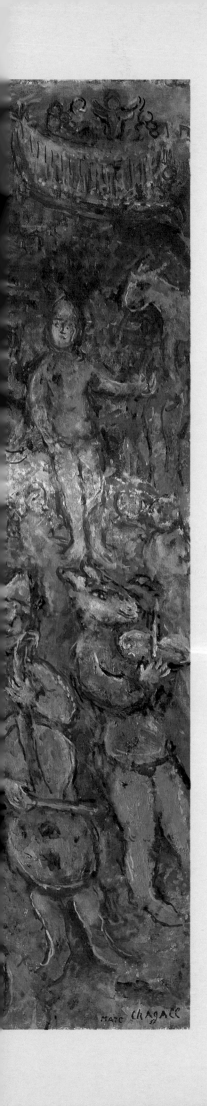

but it's *life* said he

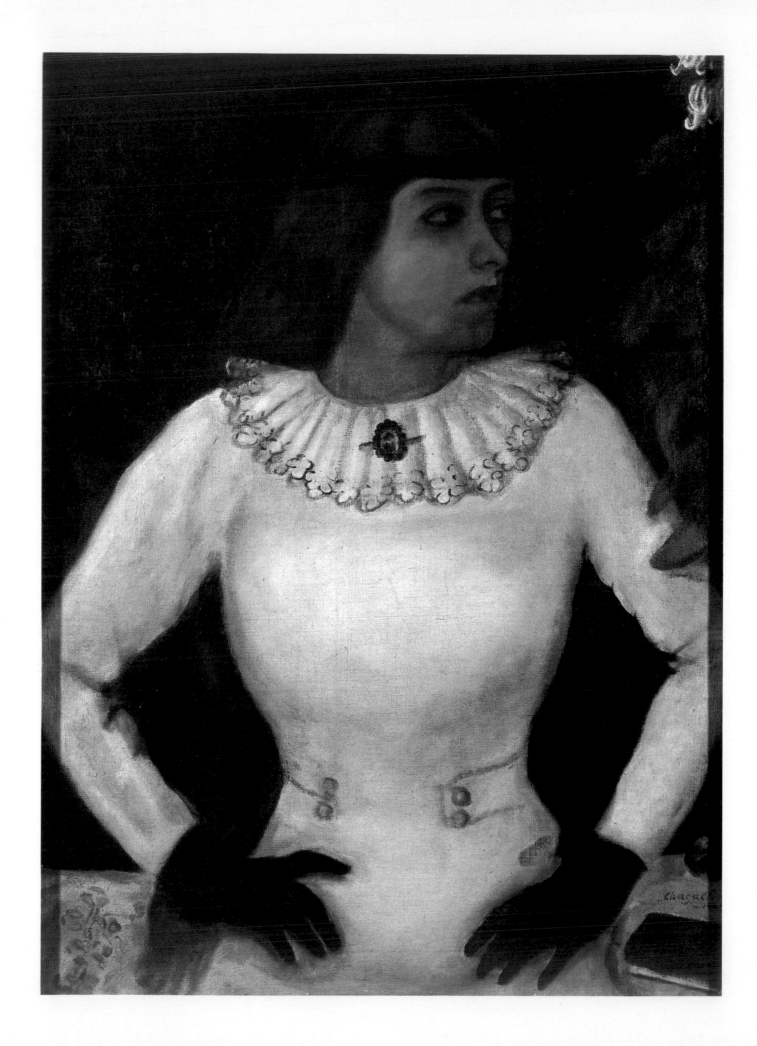

but your *wife* said she

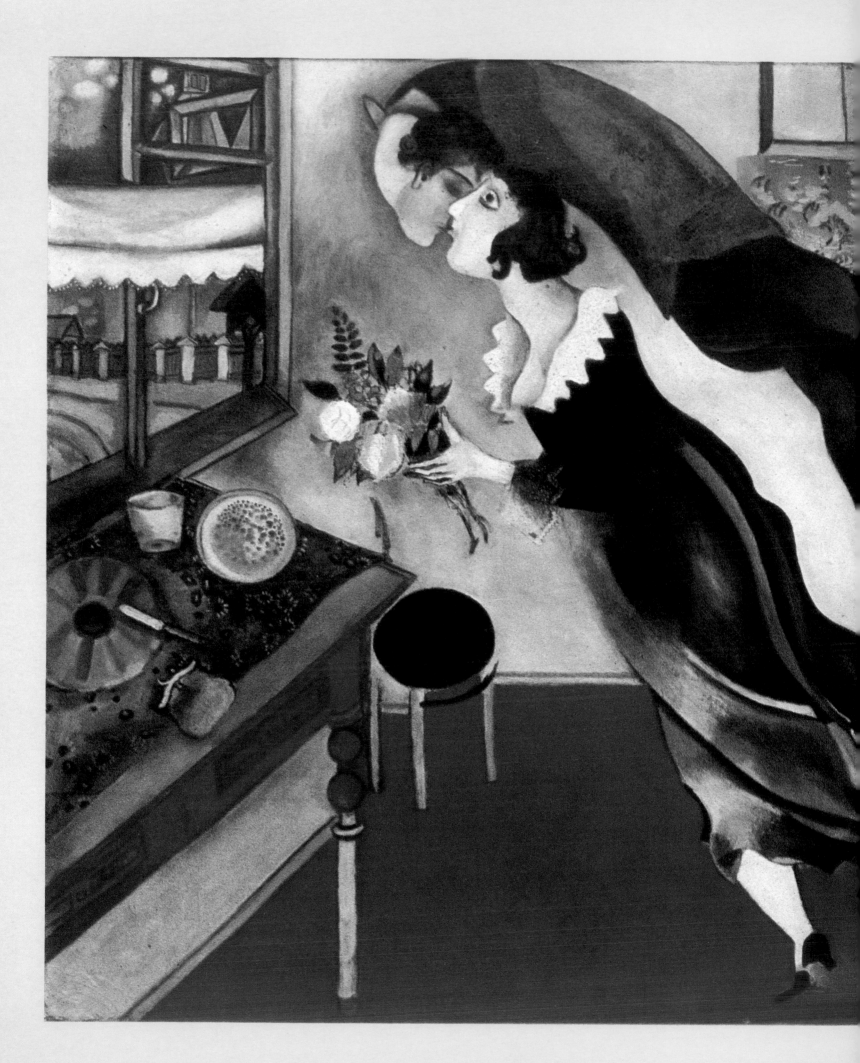

ṅöw̃
said he)

ow̃ said she

(tiptop said he

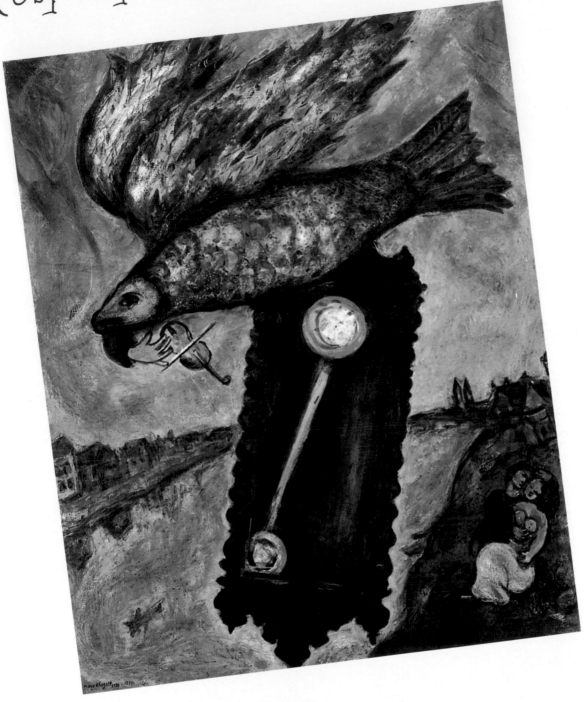

don't stop said she
oh no said he)

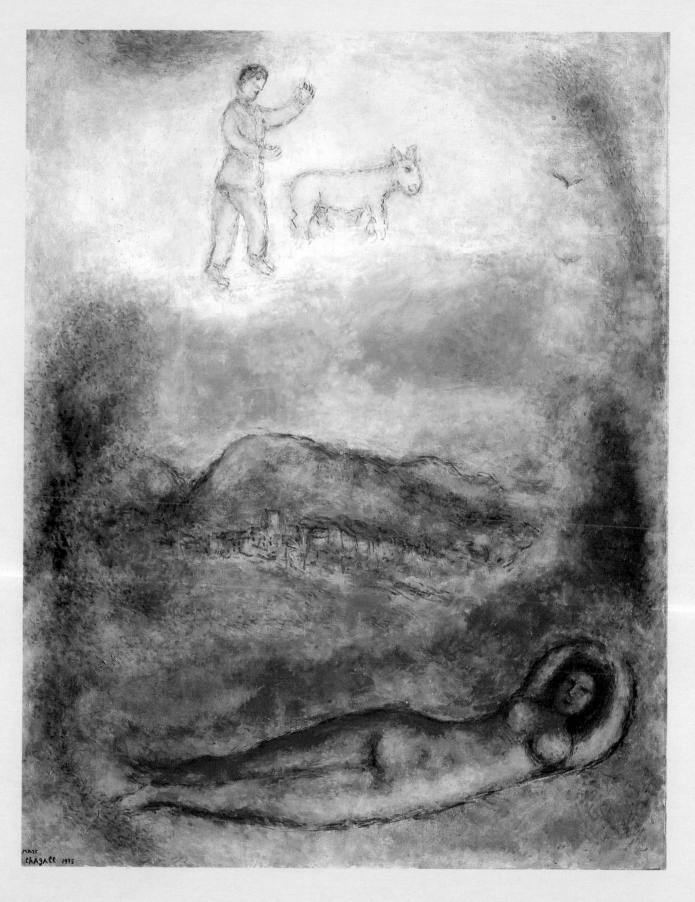

go *slow* said she

(cccome? said he

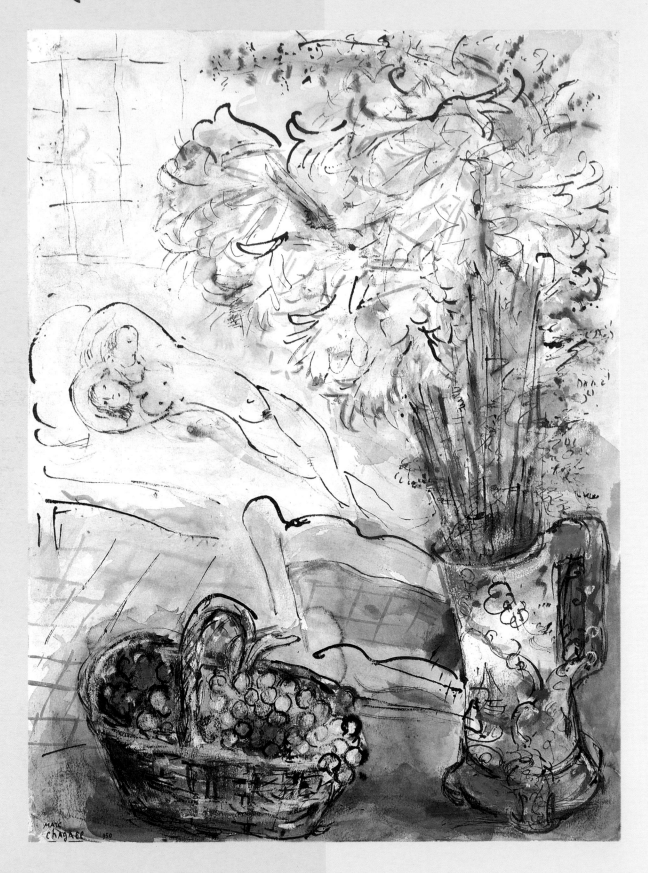

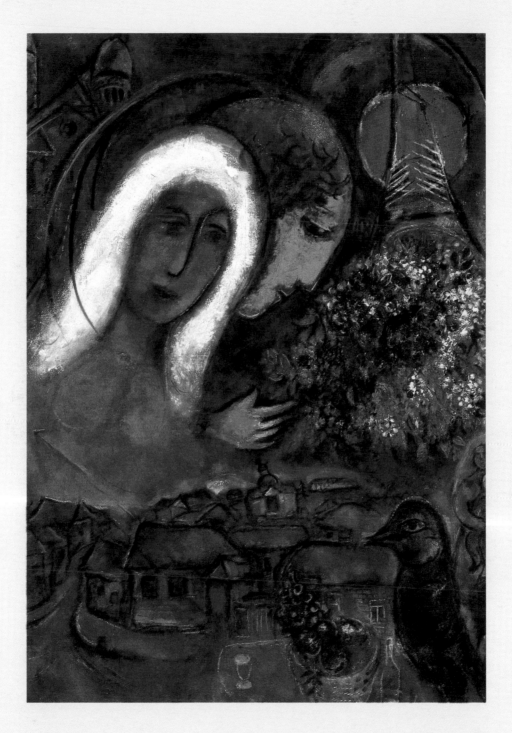

ummm said she)

you're divine! said he

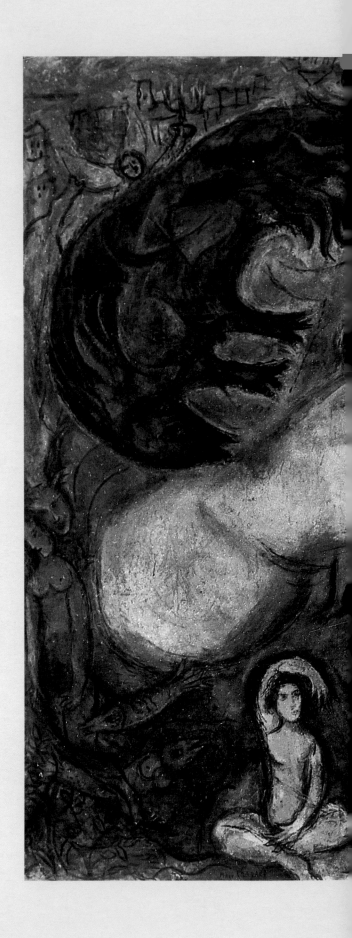

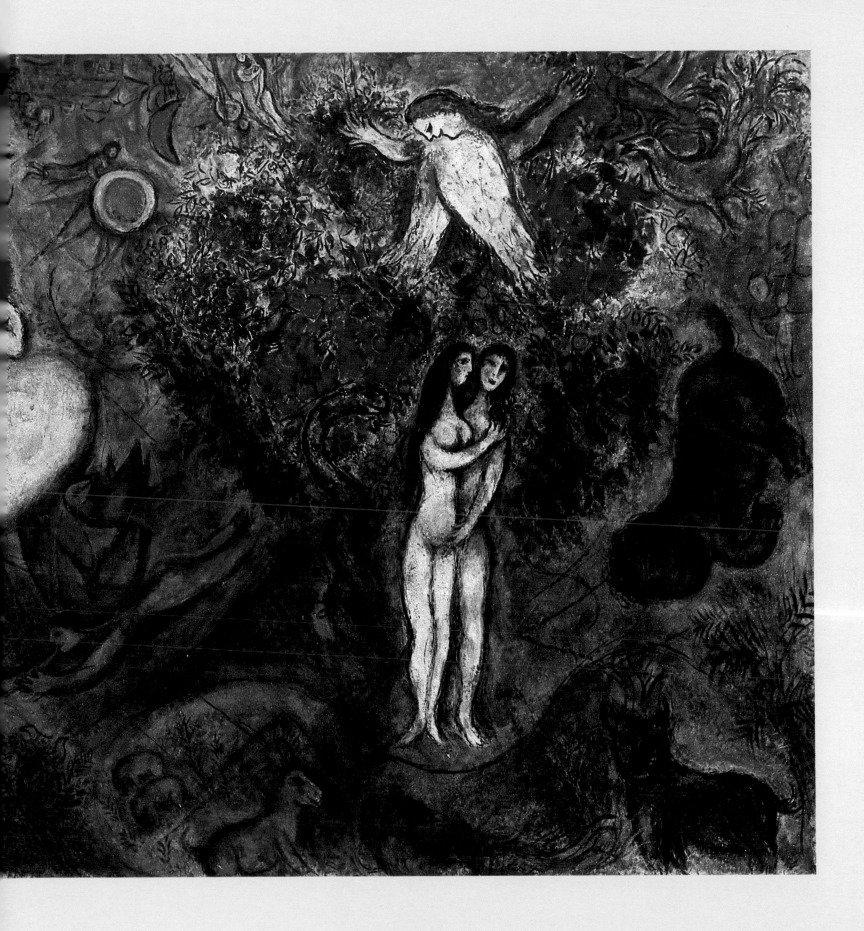

(you are Mine said she)

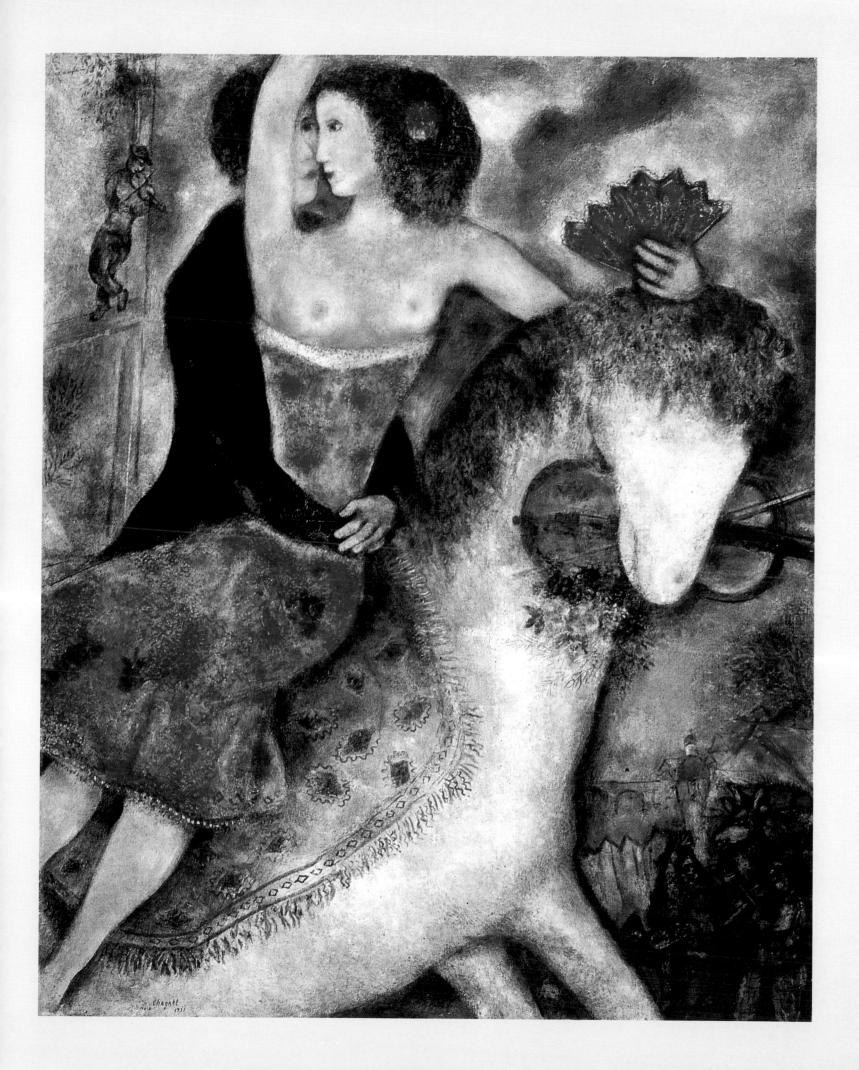

may i *feel* said he

By E. E. Cummings

may i feel said he
(i'll squeal said she
just once said he)
it's fun said she

(may i touch said he
how much said she
a lot said he)
why not said she

(let's go said he
not too far said she
what's too far said he
where you are said she)

may i stay said he
(which way said she
like this said he
if you kiss said she

may i move said he
is it love said she)
if you're willing said he
(but you're killing said she

but it's life said he
but your wife said she
now said he)
ow said she

(tiptop said he
don't stop said she
oh no said he)
go slow said she

(cccome?said he
ummm said she)
you're divine!said he
(you are Mine said she)

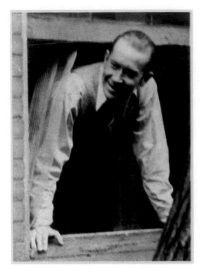

E. E. CUMMINGS

*if you like my poems let them
walk in the evening,a little behind you*

—E. E. CUMMINGS

Edward Estlin Cummings was born on October 14, 1894 in Cambridge, Massachusetts to Edward Cummings, a professor at Harvard, and Rebecca Clarke Cummings. His mother saved all of his papers including his first letter, written to his grandmother at the age of five:

I AM SORRY
DEAR NANA
BUT I WILL
BE A GOOD BOY

In 1899 the family bought a farm in the Sandwich Range of the White Mountains near Silver Lake, New Hampshire. Called Joy Farm, it was deeded to Cummings in 1929; it was here that Cummings would spend almost every summer of his life.

Cummings attended Harvard where he contributed poems to the Harvard *Monthly* and befriended John Dos Passos. His work was first published in *Eight Harvard Poets*, a volume financed by Dos Passos' father, after each of the eight poets promised to purchase thirty copies. While serving as a volunteer ambulance driver in France in 1918, Cummings was accused of subversion and sent to a detention camp, an experience he would later recount in his prose work, *The Enormous Room.*

After the war, he traveled extensively between New York and Europe, writing poems and painting. "Am still convinced that I am primarily a painter," he wrote his father in October of 1923. In July of 1924, he moved into a studio at 4 Patchin Place where he would live, on and off, for the rest of his life. He published several volumes of poetry, *Tulips & Chimneys, &*, and *XVI Poems*, but worldwide recognition was years away.

In 1932, after two failed marriages, Cummings met Marion Morehouse, a photographer, model, and actress, twelve years his junior. In his first letter to her he wrote: "come with me among mountains and oceans, let's change our minds, let's go away from not and from must and from if carefully into growing and into being and into loving." This was his way of inviting her away for a weekend. For the remainder of his life, they were rarely apart.

By 1933 he had won a Guggenheim Fellowship, published five volumes of poetry, a play, a collection of his art, and two prose works but lived, for the most part, on a small allowance from his mother. His

book *No Thanks* was only published because his mother paid the $300 printing costs. He dedicated the volume to the fourteen publishers who had rejected the work.

He continued to publish through the war, but he became more and more reclusive. He suffered from back pains and other ailments but focused his energy on work which, he felt, could only be accomplished in solitude. Marion began answering his phone and dealing with the outside world for him, keeping people away.

In 1952 he agreed to give six lectures at Harvard for $15,000. The lectures proved to be an unexpected success. He discovered he had a real talent for reading his poetry and, at the age of fifty-eight, embarked on a new career on the lecture circuit. He began to earn a living by reading at colleges, universities, art centers, and museums in New York, Washington, DC, and Chicago. He became one of the best known poets in America, which helped sales of his books, but more importantly, he seemed to enjoy the attention of the audience. In 1958 he was awarded the Bollingen Prize in Poetry from Yale University.

On September 3, 1962, Cummings died suddenly, of a cerebral hemorrhage, at Joy Farm. He was sixty-eight years old.

In a letter to his daughter dated September 7, 1959, he wrote: "Anyhow:from my standpoint the only thing—if you're some sort of artist—is to work a little harder than you can at being who you are:while if you're an unartist(i.e. aren't)nothing but big&quick recognition matters." Today, E. E. Cummings is considered by many to be the major American poet of his generation.

MARC CHAGALL

*I try to create as much as I can
with my heart, in the brotherhood
of the heart.*

—Marc Chagall

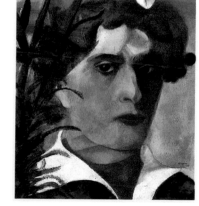

The eldest of eight children, Moshko Chagall was born on July 7, 1887, in the Russian village of Pestkowatik, on the outskirts of Vitebsk, near the Russian–Polish border. In his autobiography, he wrote that his birthplace reminded him of "a potato tossed into a barrel of herring and soaked in pickling brine." He moved to St. Petersburg but eventually went to live in Paris, which he called *"Mon second Vitebsk,"* and claimed "My art needed Paris like a tree needs water."

Chagall received his first recognition as an artist in 1914 with a one-man show in Berlin. Shortly after, while he was visiting Russia for a wedding, Germany declared war and Chagall was trapped in his homeland. He began a project to paint every aspect of life in Vitebsk, producing sixty paintings and drawings in one year. From these and other later paintings, Vitebsk would be immortalized in Chagall's images of flowers, churches, farmers, fiddlers, rabbis, peasants, cows, lovers, fish, and donkeys floating through the air. Chagall portrayed a topsy-turvy world where roosters crowed for joy and bird-headed humans played instruments. The critic André Breton wrote, "With Chagall alone . . . metaphor makes its triumphant entry into modern painting."

In 1915 Chagall married Bella Rosenfeld, daughter of the richest family in Vitebsk, despite objections from her family. Their daughter Ida was born in 1916. After the war, Chagall received word that his work was selling in Germany and in the summer of 1922 traveled to Berlin. At the suggestion of publisher Paul Cassirer, he learned the craft of etching to illustrate such books as Nikolai Gogol's *Dead Souls*.

The Chagalls were living in Paris when war broke out again in 1939 and the Museum of Modern Art invited the family to live in New York. He asked, "Are there trees and cows in America, too?" In May of 1941, the family settled in Manhattan where they lived as refugees for the next seven years, refusing to speak English. His work was shown by Pierre Matisse, son of Henri. He worked for the Ballet Theater of New York on *Alekop* and other ballets.

On a visit to the Adirondacks, his wife Bella took sick. He later wrote, "A loud cloud of thunder and a burst of rain broke out at six o'clock in the evening of the 2nd of September, 1944, when Bella left this world. Everything went dark before my eyes." Chagall turned all his canvases to the wall and was unable to work for nine months.

By the time he was fifty, he had gained worldwide recognition. After the war, major exhibitions of his work were shown at MOMA and the Art Institute of Chicago. In 1948, he moved back to France where he bought a home in Vence, a small town above the Riveria. In 1952, he married Valentine Brosky.

He continued to paint and work extensively in the theater. He created a huge circular painting for the ceiling of the Paris Opera House and two enormous murals for the Metropolitan Opera House at Lincoln Center. He worked in ceramics, mosaics, sculptures, and tapestries. "I work in whatever medium likes me," he claimed.

At the age of seventy, he mastered the art of stained glass. When twelve of his windows were displayed at MOMA before being installed at the Hadassah Medical Center in Jerusalem, people lined the streets for half a mile. Chagall was so popular that, on his eightieth birthday, it took Madame Chagall and a team of secretaries several days to open all the cards and gifts that had arrived from around the world.

In 1977, at age ninety, Chagall was awarded the Grand Cross of the Legion of Honor by France, traveled to Italy and Israel, and worked on stained-glass windows for the Art Institute of Chicago. The Louvre had a show of sixty-two paintings that Chagall had painted in his eighties, which were praised as among his best work. He continued working right up to the day he died in January 1985, at the age of ninety-seven.

All paintings by Marc Chagall Copyright © 1995 Artists Rights Society (ARS) NY/ADAGP, Paris.

"may i feel said he" reprinted from *No Thanks* by E.E. Cummings. Edited by George James Firmage. By permission of Liveright Publishing Corporation. Copyright © 1935 by E.E. Cummings. Copyright © 1968 by Marion Morehouse Cummings. Copyright © 1973, 1978 by the Trustees for the E.E. Cummings Trust. Copyright © 1973, 1978 by George James Firmage.

Compilation copyright © 1995 by Welcome Enterprises, Inc.

Edited by Linda Sunshine
Designed by Mary Tiegreen

Published in 1995 by Welcome Enterprises, Inc.
575 Broadway, New York, NY 10012
Distributed by Stewart, Tabori & Chang, Inc.
575 Broadway, New York, NY 10012
Distributed in Canada by General Publishing Co., Ltd.
30 Lesmill Road, Don Mills, Ontario, Canada, M3B 2T6
Distributed in the U.K. by Hi Marketing
38 Carver Road, London, SE24 9LT, England
Distributed in Australia and New Zealand by Peribo Pty Limited
58 Beaumont Road, Mount Kuring-gai, NSW 2080, Australia

All rights reserved. No part of the contents of this book may be reproduced by any means without the written permission of the publisher.

Library of Congress Cataloging-in-Publication Data:
Cummings, E. E. (Edward Estlin), 1894–1962.
 May I feel said he : poem / by E. E. Cummings ; paintings by Marc Chagall ; edited by Linda Sunshine.
 p. cm.
 ISBN 0-941807-00-2
 I. Chagall, Marc, 1887–1985. II. Sunshine, Linda. III. Title.
PS3505.U334M38 1995
811' .52--dc20

ILLUSTRATION CREDITS:
FRONT COVER: *Double Portrait with Wine Glass*, 1917. Musée National d'Art Moderne, Centre Georges Pompidou, Paris. Photo: Scala/Art Resource, New York.
BACK COVER: *Birthday*, 1915. Collection, photo © 1995 The Museum of Modern Art, New York.

PAGE 1: *The Juggler*. Private Collection, New York. Photo: Giraudon/Art Resource, New York.
PAGE 2: *Nude*, 1913. Thyssen-Bornemisza Museum, Madrid. Photo: Scala/Art Resource, New York.
PAGE 3: *The Flower Parade*. Private Collection. Photo: Edward Owen/Art Resource, New York.
PAGE 4: *Clown with Mandolin*, 1975–76. Private Collection. Photo: Scala/Art Resource, New York.
PAGE 5: *Angel and the Reader*, 1930s. The Art Institute of Chicago.
PAGE 6: *Souvenirs*, 1976. Private Collection, St. Paul de Vence, France. Photo: Scala/Art Resource, New York.
PAGE 7: *The Branch*, 1976. Private Collection, St. Paul de Vence, France. Photo: Scala/Art Resource, New York.
PAGE 8: *Flowers Over Paris*, 1967. Collection Chagall, St. Paul de Vence, France. Photo: Scala/Art Resource, New York.
PAGE 9: *Double Portrait with Wine Glass* (*see* FRONT COVER).
PAGE 10: *The Yellow Room*. Private Collection, Switzerland. Photo: Giraudon/Art Resource, New York.
PAGE 11: *The Rooster*, 1928. Thyssen-Bornemisza Museum, Madrid. Photo: Scala/Art Resource, New York.
PAGES 12–13: *The Dream*, 1939. The Phillips Collection, Washington, DC.
PAGE 14: *Red Roofs*, 1953. Musée National d'Art Moderne, Centre Georges Pompidou, Paris.
PAGE 15: *Homage to Apollinaire*, 1912–13. Stedelijk van Abbemuseum, Eindhoven, The Netherlands.
PAGES 16–17: *At the Circus*, 1976. Private Collection, St. Paul de Vence, France. Photo: Scala/Art Resource, New York.
PAGE 19: *Portrait of My Fiancée in Black Gloves*, 1909. Oeffentliche Kunstsammlung, Kunstmuseum, Basel, Switzerland. Photo: Scala/Art Resource, New York.
PAGES 20–21: *Birthday* (*see* BACK COVER).
PAGE 22: *Time is a River Without Banks*, 1931. Photo © 1995 The Museum of Modern Art, New York.
PAGE 23: *The Sleep*. Private Collection, St. Paul de Vence, France. Photo: Scala/Art Resource, New York.
PAGE 24: *Couple with Bouquet of Flowers and Fruit Basket*, 1950. Private Collection. Photo: Art Resource, New York.
PAGE 25: *Le Champ de Mars*, 1954–55. Museum Folkwang, Essen.
PAGES 26–27: *The Paradise*. Musée National-Message-Biblique-Marc Chagall, Nice, France. Photo: Art Resource, New York.
PAGES 28–29: *The Equestrian*. Stedelijk Museum, Amsterdam.
PAGE 30: Photograph of E.E. Cummings at his studio window, 4 Patchin Place, New York. Reprinted by permission of Houghton Library, Harvard University. Photo: David Dunham.
PAGE 31: *Self Portrait*, 1914. Philadelphia Museum of Art: The Louis E. Stern Collection, Philadelphia.